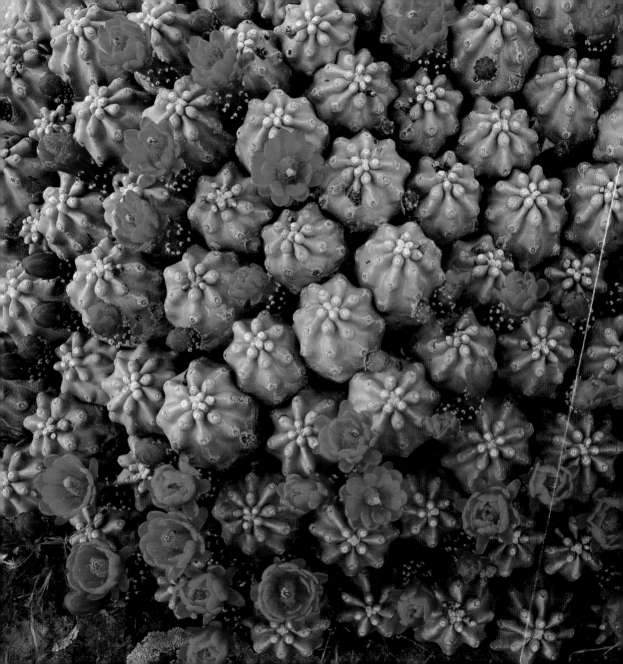

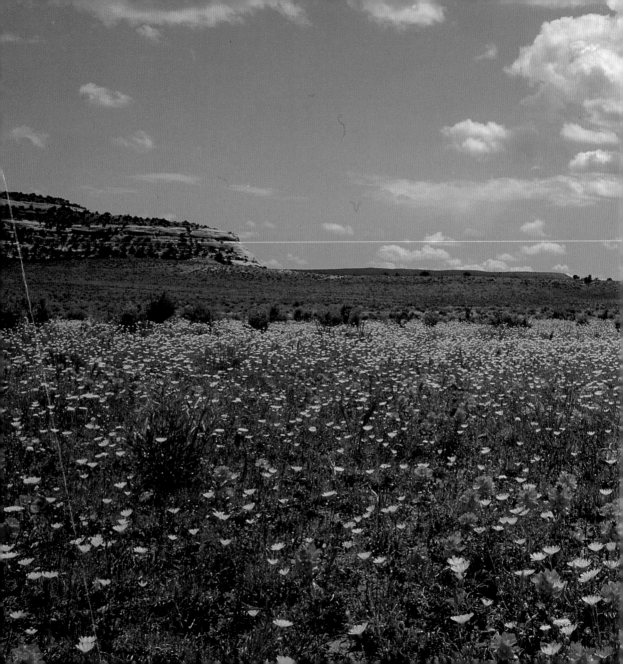

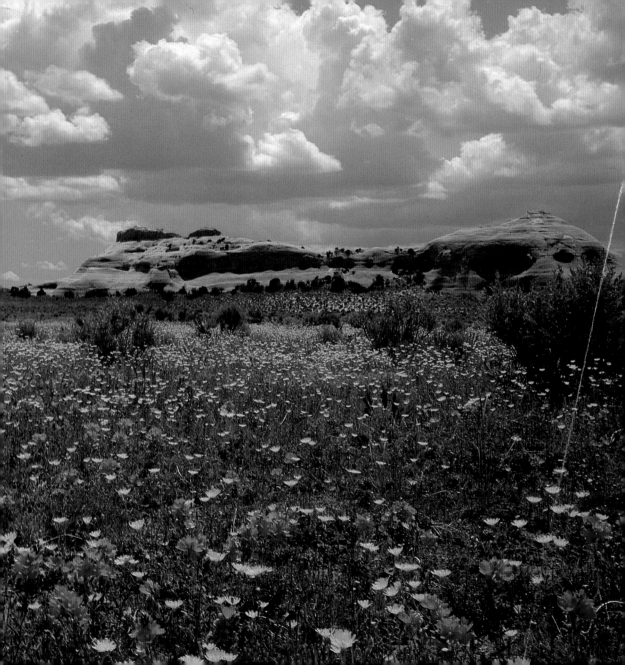

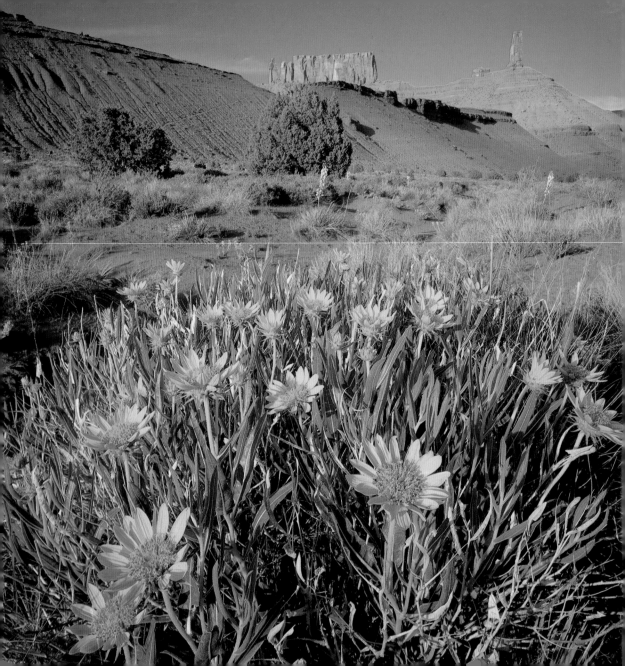

UTAH WILDFLOWERS

Photography by Tom Till
With Selected Prose & Poetry

Utah Littlebooks

Westcliffe Publishers, Inc., Englewood, Colorado

First frontispiece: Spineless hedgehog cactus, La Sal Mountains
Second frontispiece: Field of globemallow, Lisbon Valley
Third frontispiece: Mule's ear, near Castle Rock
Opposite: Columbine, Desolation Canyon Wilderness Study Area

International Standard Book Number: 1-56579-140-1
Library of Congress Catalog Number: 95-62428
Copyright Tom Till, 1996. All rights reserved.
Published by Westcliffe Publishers, Inc.
2650 South Zuni Street, Englewood, Colorado 80110
Publisher, John Fielder; Editor, Suzanne Venino; Designer, Amy Duenkel
Printed in Hong Kong by Palace Press

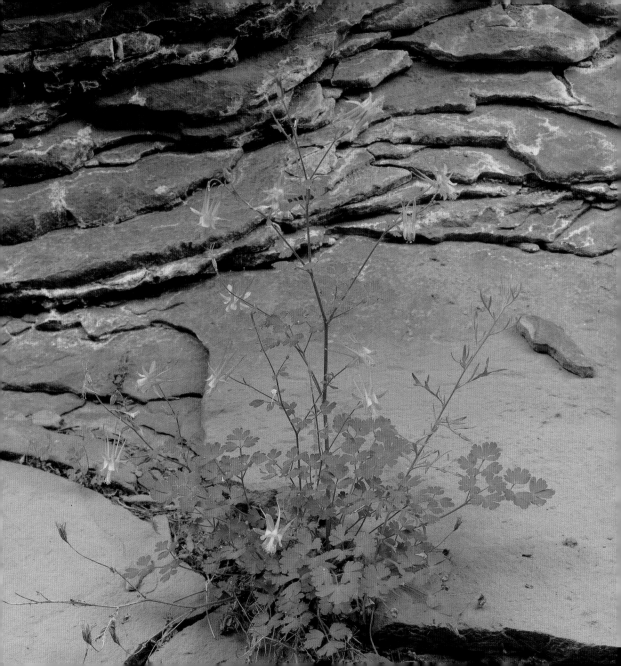

PREFACE

Whether blooming in a meadow high in Uinta National Forest, filling a graben in Canyonlands National Park, or sprouting near a hidden spring, wildflowers are the spice and, at times, the crowning glory of the Utah landscape. In one of the most arid regions in the United States, coming upon a field of spring blossoms is an unforgettable experience.

In dry years, large flower displays may be nonexistent, although flowers near seeps can usually be expected to bloom with the continual supply of moisture. After the wet and cold winter of 1978-1979, many fields of flowers bloomed in southern Utah that have not blossomed since. A huge expanse of lupine filled Richardson Amphitheater below Fisher Towers and Castle Rock, while acres of Spanish Valley were covered with yellow bee plant. There have been several wet years since, but none has had the sufficient amount of rain or snow at just the right time to produce the glories of that year.

Some years also have the perfect alchemy to produce large numbers of blooms on the cactus of Utah's deserts. In 1978, on one of the first walks I ever took with a large-format camera, I found a magnificent claret cup cactus in a small canyon near Moab. For the next several years I photographed the cactus every spring, hiking to it practically every day to monitor the blossoms and make an image at its peak. This huge clump of cactus was nearly four feet in diameter, standing about two feet above the sandy soil. At its blooming climax, the dome held dozens of crimson flowers — a spectacular sight.

One spring, when I hiked to the cactus for the first time that season, I found the plant nearly destroyed. A piece of the nearby rock wall had fallen, crushing most of the plant under the rubble. I've gone back many times since, but the beautiful display shows no sign of returning to its former glory. Ironically, it's near a pictograph panel that has been severely

Penstemon blooms, Wasatch Range

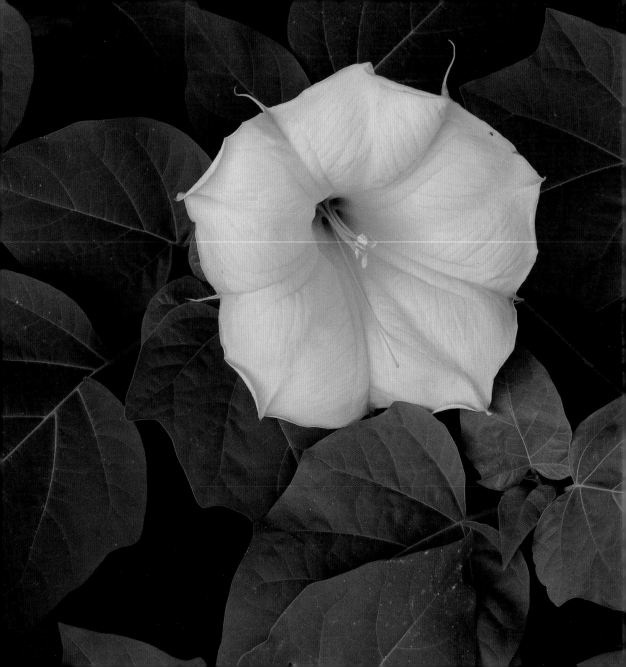

vandalized by that other force of nature: man.

Humans are also having an impact on one of the West's most abundant blooming sites. High in a Wasatch Range valley, wildflowers bloom on scale seen in few other places. Although the kinds of flowers and their dispersion varies considerably from year to year, this small area is truly a wildflower paradise.

Unfortunately, the impact of visitors has significantly affected the numbers and variety of summer blooms. I often see hikers carrying large bouquets as they travel the trails, and with the ever-increasing visitation from the burgeoning Wasatch Front population, the consequences could be severe. I implore you to leave wildflowers in their natural setting. They should never be picked, and they should be trampled as little as possible. Please admire them and leave them for others to enjoy.

In his poem "A Tuft of Flowers," Robert Frost tells the story of finding a small group of wildflowers left by a mower. The speaker feels a great kinship with a person he's never met because of the unselfish act of saving some small bit of beauty in an often ugly world. Wildflowers do that for us. They show us a glimpse of the best that life has to offer. Small and delicate, colorful and audacious, their beauty is a bold assault on the drab, the mundane, and the melancholy.

— Tom Till
Moab, Utah

Datura flower, Canyonlands National Park

"To create a little flower is the labour of ages."

— William Blake, *Proverbs of Hell*

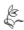

Cliffrose below Courthouse Towers, Arches National Park

"Beauty is truth, truth beauty—

that is all

Ye know on earth,

and all ye need to know."

— John Keats, *Ode to a Grecian Urn*

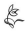

Groundsel at the base of Stewart Cascades,
Uinta National Forest

"Nothing in the world is single,

All things by law divine

In one spirit meet and mingle."

— Percy Bysshe Shelley, *Love's Philosophy*

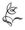

Bee flowers, Dinosaur National Monument

"Spring lightens the green stalk, from thence the leaves
More aerie, last the bright consummate flower."

— John Milton, *Paradise Lost*

Primrose, Zion National Park

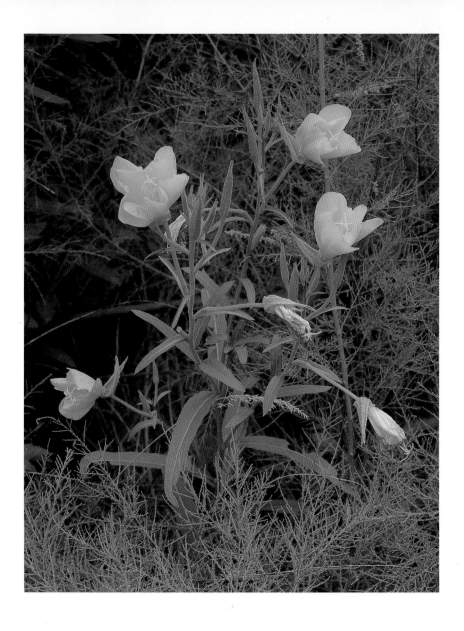

"I should like to enjoy this summer

flower by flower..."

— Andre Gide, *Journals*

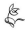

Sunflowers beneath Sundial Peak, Twin Peaks Wilderness

Overleaf: Indian paintbrush, Wasatch National Forest

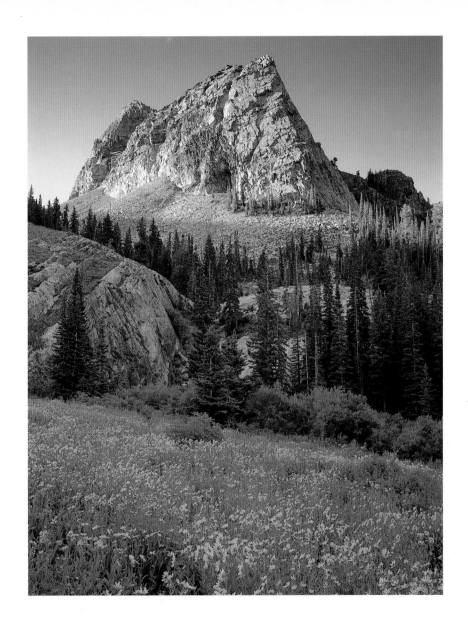

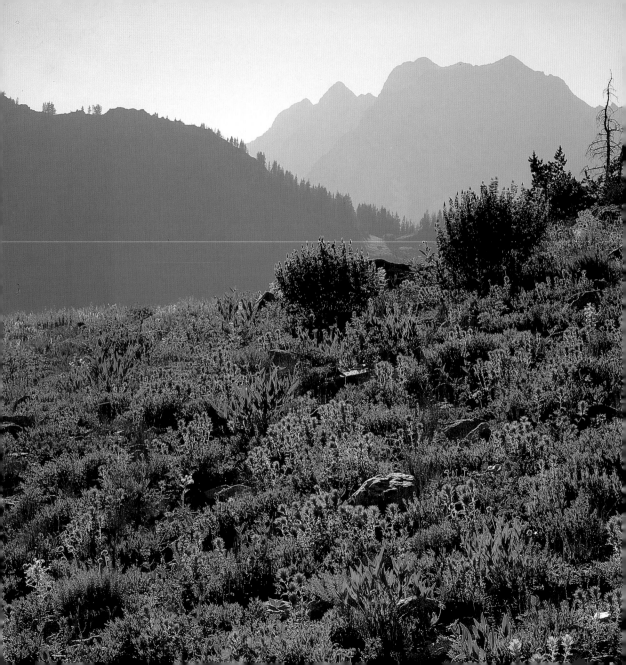

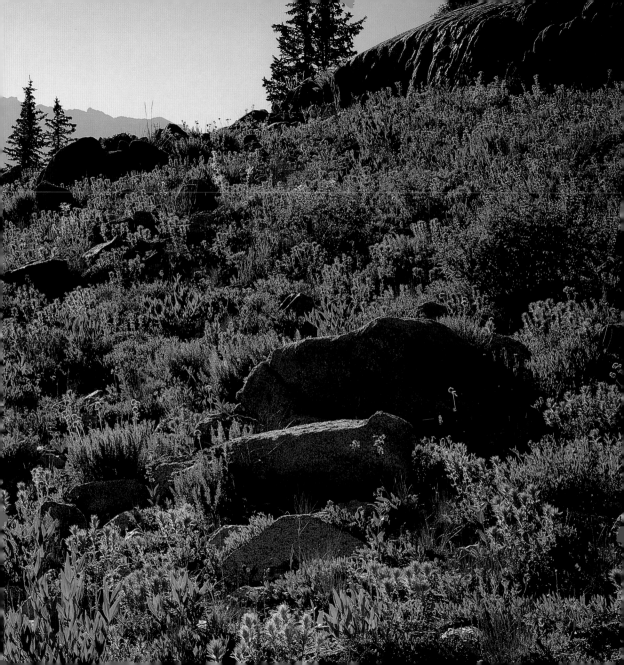

"Flowers...are like lipstick on a woman — it just
makes you look better to have a little color."

— Lady Bird Johnson,
Time magazine, September 5, 1989

Indian paintbrush, Arches National Park

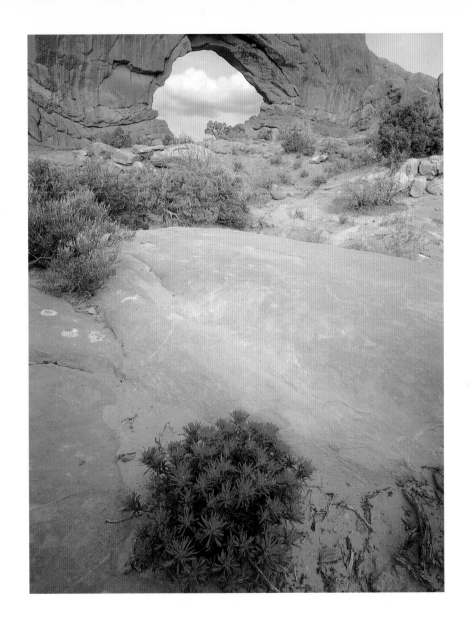

"Throw hither all your quaint enamell'd eyes
That on the green turf suck the honied showers,
And purple all the ground with vernal flowers."

— John Milton, *Lycidas*

Purple columbine, Flaming Gorge National Recreation Area

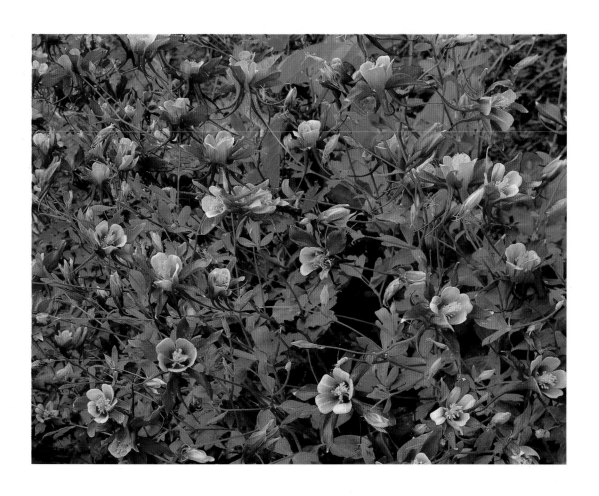

"Flowers are words

Which even a baby may understand."

— Arthur C. Coxe, *The Singing of Birds*

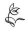

Goldenrod and Anasazi ruins, BLM Wilderness Study Area

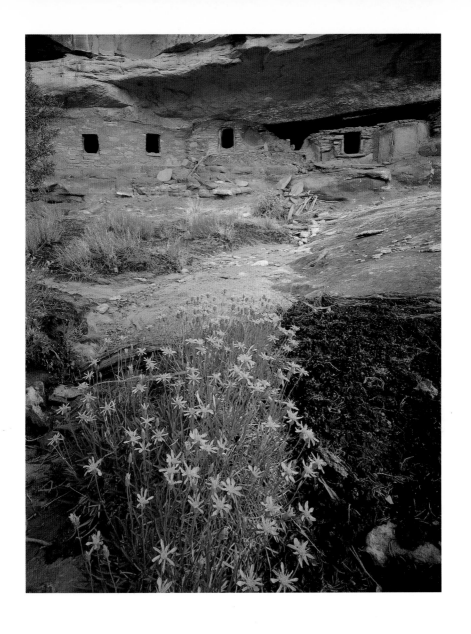

"How does the meadow-flower its bloom unfold?

Because the lovely little flower is free

Down to its root, and, in that freedom bold."

— William Wordsworth, *A Poet! He Hath Put His Heart to School*

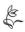

Bluebells, Manti-La Sal National Forest

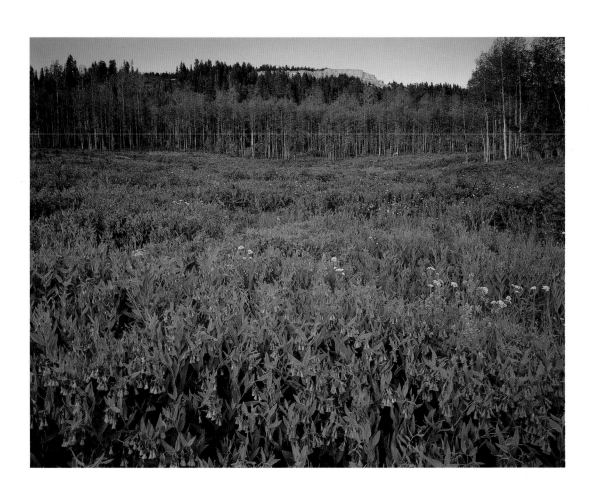

"The flower is the poetry of reproduction. It is an
example of the eternal seductiveness of life."

— Jean Giraudoux, *The Enchanted*

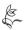

Claret cup cactus, Arches National Park

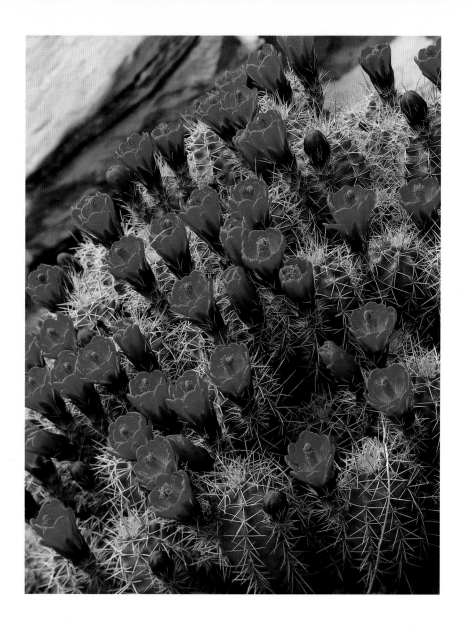

"Nothing is so like a soul as a bee. It goes from
flower to flower as a soul from star to star,
and it gathers honey as a soul gathers light."

— Victor Hugo, *Ninety-Three*

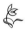

Indian paintbrush, Mount Timpanogos Wilderness

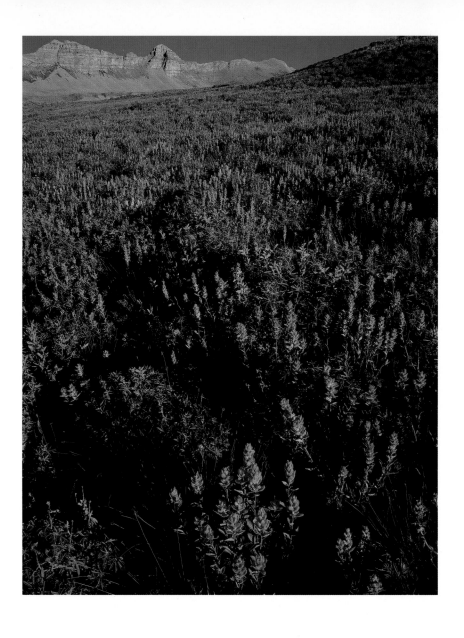

"Beauty is its own excuse for being."

— Ralph Waldo Emerson, *The Rhodora*

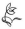

Purple thistle among ruins, Wasatch Range

Overleaf: Yellow monkeyflowers, Phipps-Death Hollow Wilderness Study Area

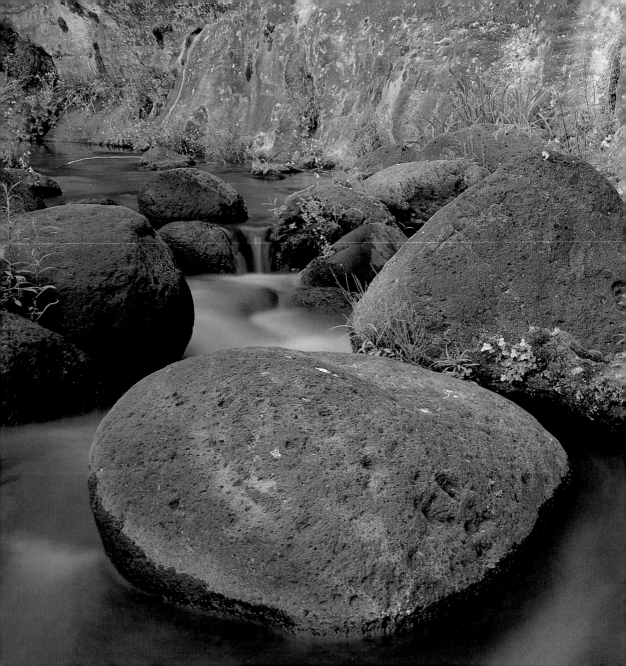

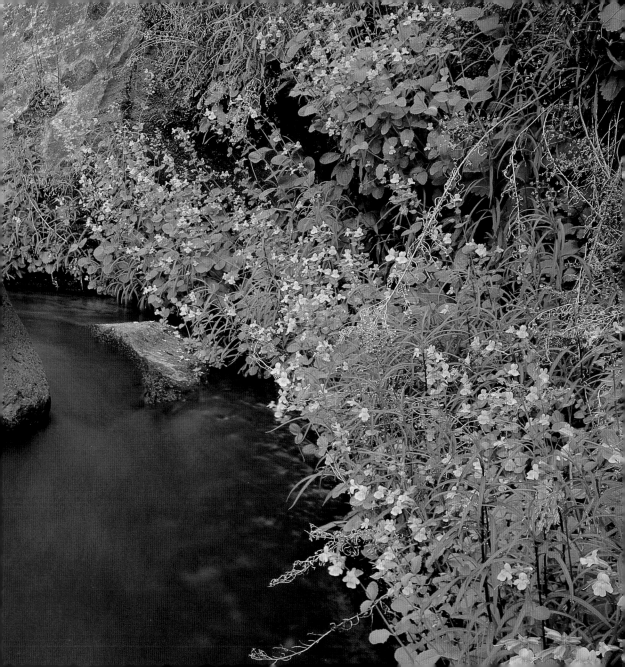

"A charm that has bound me with the witching power,

For mine is the old belief,

That midst your sweets and midst your bloom,

There's a soul in every leaf!"

— Maturin Murray Ballou, *Flowers*

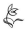

Indian paintbrush and daisies, High Uintas Wilderness

"Work — for some good, be it ever so slowly;

Cherish some flower, be it ever so lowly..."

— Frances Sargent Osgood, *Laborare est Orare*

Prickly pear cactus and bee flowers, San Rafael Swell

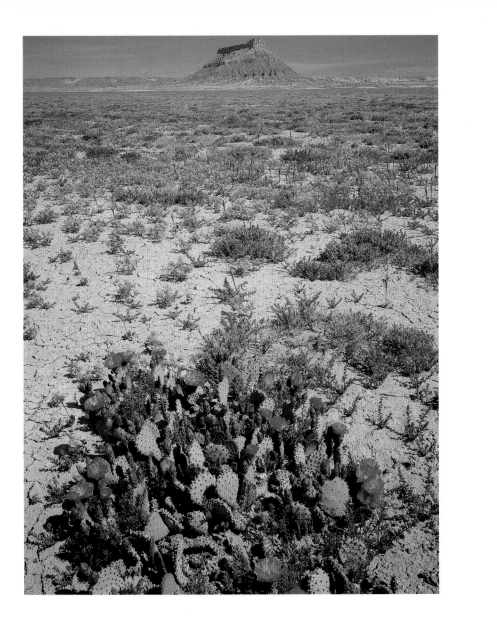

"The earth laughs in flowers."

— Ralph Waldo Emerson, *Hamatreya*

Balsamroot, Wasatch Range

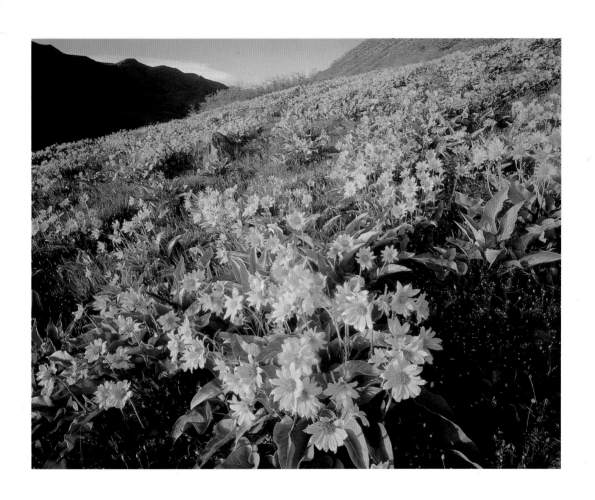

"Flowers have expression of countenance
as much as men or animals. Some seem to smile;
some have a sad expression; some are pensive and diffident;
others again are plain, honest and upright..."

— Henry Ward Beecher, *Star Papers: A Discourse of Flowers*

Desert rhubarb, Capitol Reef National Park

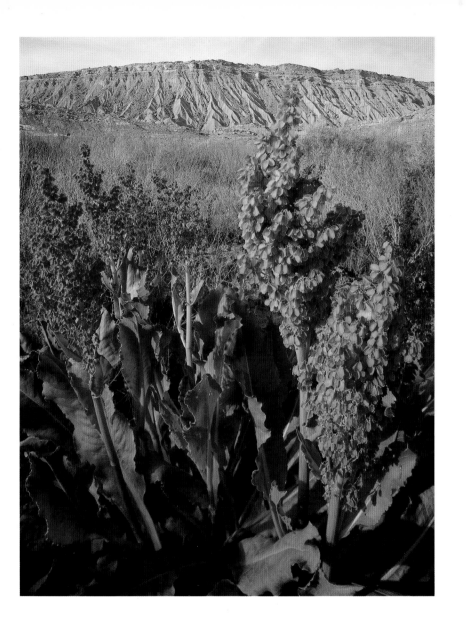

"Beauty is a primeval phenomenon, which itself never makes its appearance, but the reflection of which is visible in a thousand different utterances of the creative mind, and is as various as nature herself."

— Goethe, from Eckermann's *Conversations*

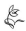

American vetch, Fishlake National Forest

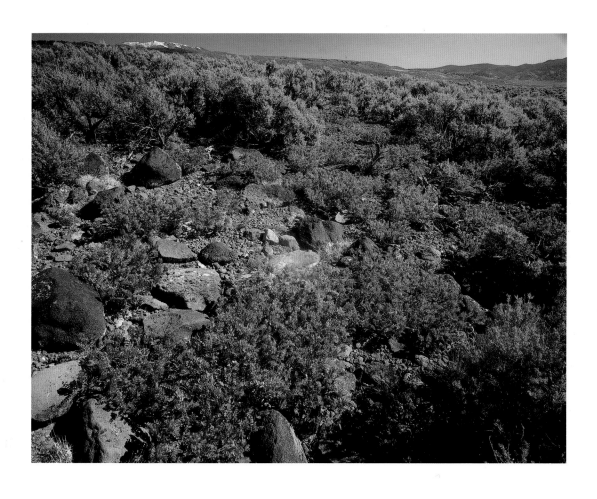

"The loveliest flowers the closest cling to earth…

The happiest of Spring's happy, fragrant birth."

— John Keble, *Spring Showers*

Bee flowers beneath Book Cliffs

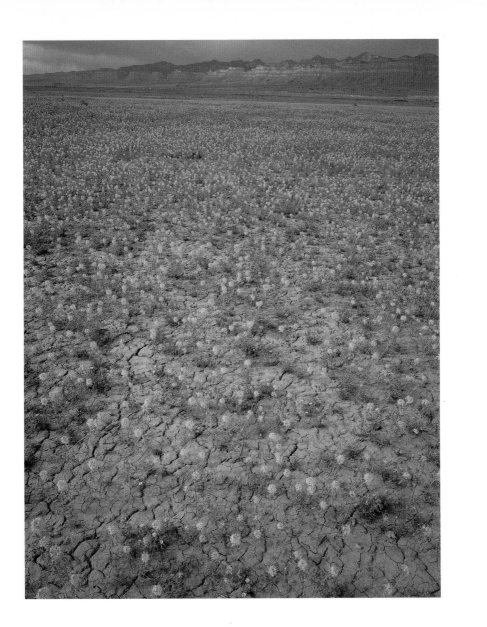

"One of the attractive things about the flowers

is their beautiful reserve."

— Henry David Thoreau, *Journal*

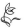

Columbine, Wasatch National Forest

Overleaf: Monitor and Merrimac Buttes, west of Arches National Park

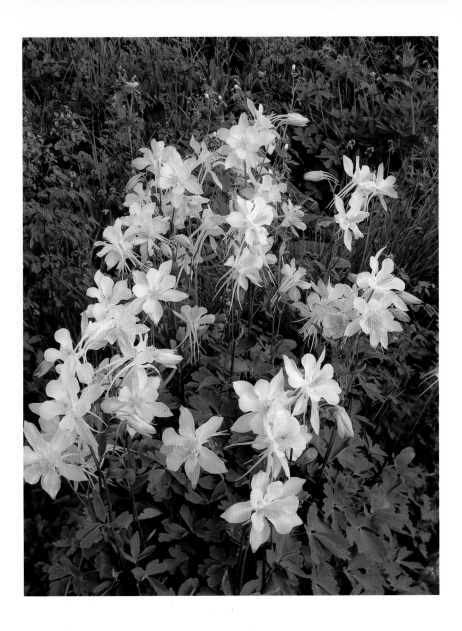

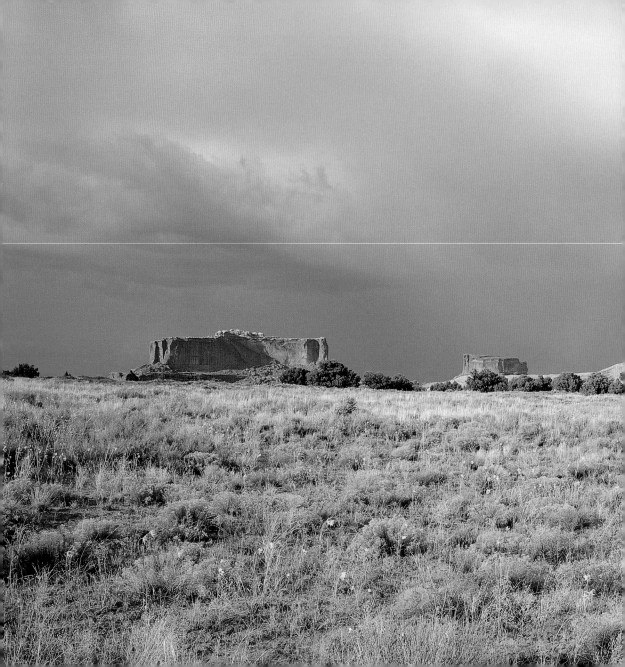

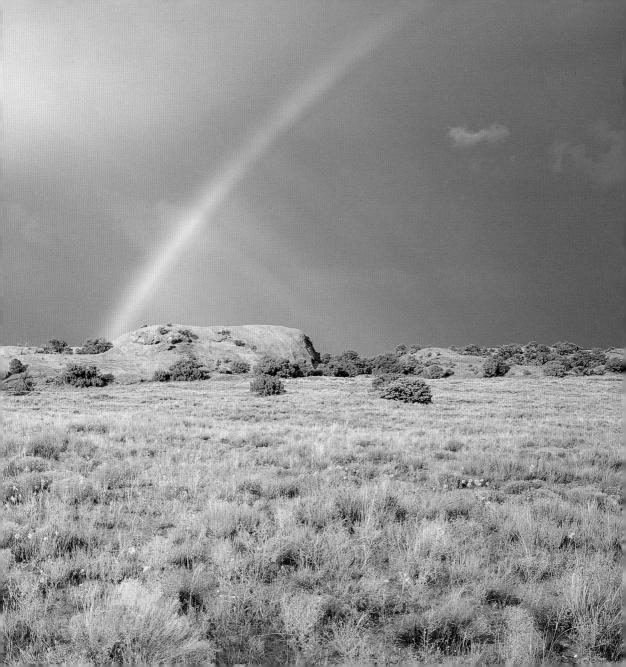

"You must not know too much, or be too precise or
scientific about birds and trees and flowers...
a certain free margin...helps your enjoyment
of these things."

— Walt Whitman, *Specimen Days*

Indian paintbrush, Wasatch National Forest

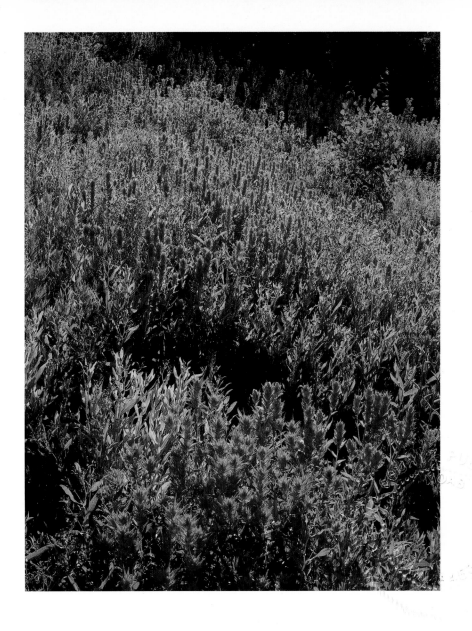

"And 'tis my faith, that every flower

enjoys the air it breathes."

— William Wordsworth, *Lines Written in Early Spring*

Yellow columbine, Zion National Park

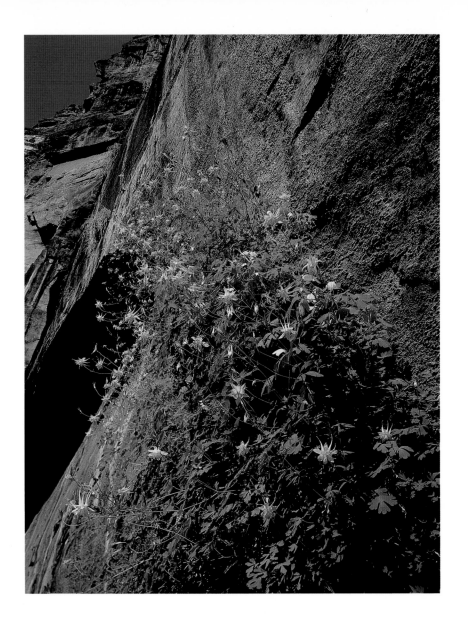

"Shed not tear — O shed not tear!

The flower will bloom another year.

Weep no more — O weep no more!

Young buds sleep in the root's white core."

— John Keats, *Faery Songs*

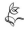

Easter flowers near a seep, Dirty Devil Wilderness Study Area

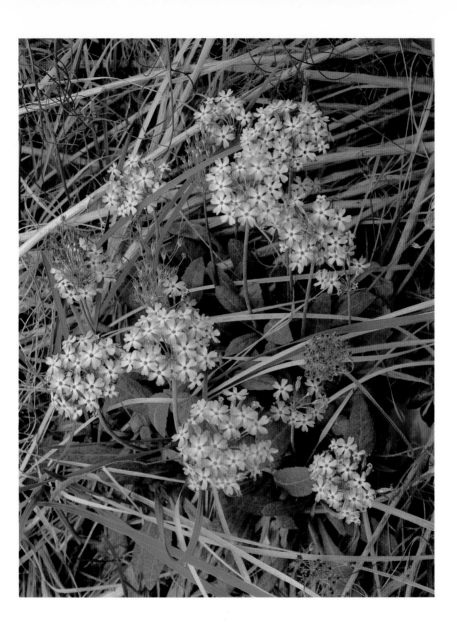

"The Amen! of Nature is always a flower."

— Oliver Wendell Holmes,
The Autocrat of the Breakfast-Table

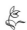

Grass widow blooms, Wasatch Range

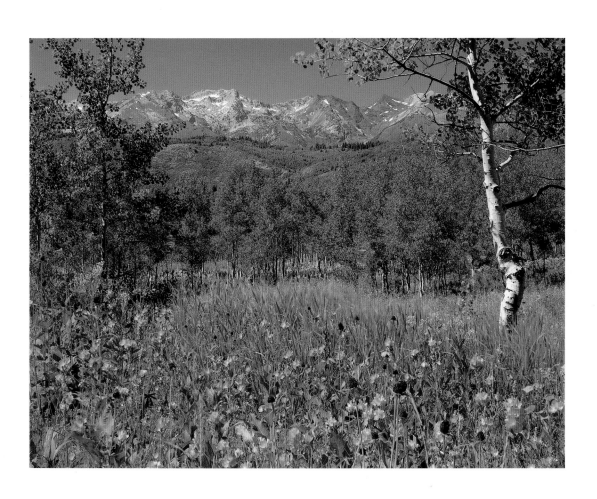

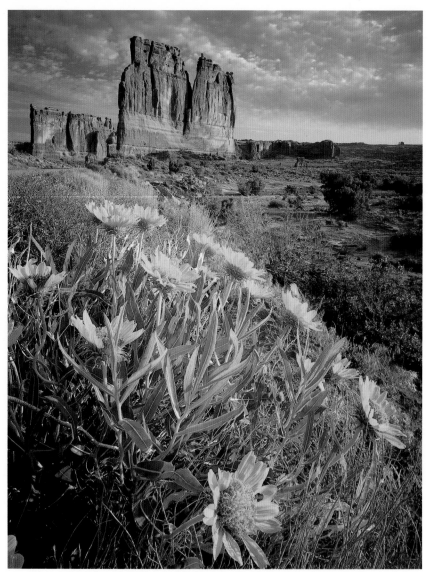

Mule's ear flowers beneath Courthouse Towers,
Arches National Park